Letters to a Young Painter

David Zwirner Books

ekphrasis

Letters to a Young Painter
Rainer Maria Rilke

Translated by Damion Searls

Contents

Introduction

Rachel Corbett

In 1902, Rainer Maria Rilke went to Paris to write a monograph about Auguste Rodin. Ten days into the trip, the young poet confessed that he had an ulterior motive for taking the assignment. "It is not just to write a study that I have come to you," he told Rodin. "It is to ask you: how should I live?"

How a person becomes an artist was the driving inquiry of Rilke's youth. In his twenties, the unknown poet pursued his heroes with the hope that they might teach him not just to write, but to look, think, and feel like an artist. He sought the mentor who might mold him like the raw material he described in one early autobiographical verse: "I am still soft, and I can be like wax in your hands. Take me, give me a form, finish me."

Not many people could tolerate the needy young writer's nagging questions for long, however. Leo Tolstoy sent Rilke away after one afternoon. The writer Lou Andreas-Salomé, his former lover, advised him for a while—improving his handwriting and masculinizing his name from René to Rainer—but then declared in 1901, "*He must go!*" Rilke took these rejections hard, but he persisted in his search, writing in his journal at the time that he still believed "without doubt there exists somewhere for each person a teacher. And for each person who feels himself a teacher there is surely somewhere a pupil."

For Rilke that teacher would be Rodin, the then sixty-two-year-old master who had just finished *The Thinker*. Rodin, isolated and lacking a pupil indeed, gave Rilke a simple answer to his immense question. "You must

work, always work," Rodin said. Do not waste time with wives and children. Do not indulge in fancy food or wine. Do not sit on cushions—"I do not approve of half going to bed at all hours of the day," Rodin once said.

Rilke took this message to heart. He largely abandoned his new wife and daughter in Germany and stayed in Paris on and off over the next six years, first as a disciple of Rodin's and later as his secretary. He lived in near poverty, devoting himself only to his work. When Rilke received a letter during this first sojourn in Paris from an Austrian military school student who aspired to be a poet, Franz Xaver Kappus, Rilke passed on some wisdom from Rodin, instructing him to "write about what your everyday life offers you." Then he added a note of bittersweet encouragement: "Love your solitude and try to sing out with the pain it causes you."

That advice appears in the first of the ten letters that would become the book *Letters to a Young Poet*, the beloved guide not just to writing but to navigating the solitude, anxiety, and poverty that so often attend creative life. Rilke is best known in America for this collection, originally published in 1929, three years after his death, but what readers often don't know is that Rilke was himself a young poet of just twenty-seven when he began writing it. What is even less known is that there is a second series of letters by Rilke to an aspiring artist—the teenage painter Balthus—written at the very end of Rilke's life. First published in French in 1945, *Letters to a Young Painter* appears here in English for the first time.

These two collections bookend Rilke's life. Taken together, the reader witnesses the transition of the artist from disciple to master. By the time Rilke was writing to Balthus, between 1920 and 1926, he was a celebrated poet living in Switzerland, in a small "stouthearted castle," Château Berg-am-Irchel.

But fame hadn't brought him happiness. Devastated by the First World War, he could no longer bear to even hear his native German tongue. He started writing in French instead, and changed his name from Rainer back to René. He had also begun to lament taking Rodin's advice so literally. He had spent decades in near solitude, living only through his work. The more he thought about it, the more he began to see Rodin's hypocrisy. The sculptor had indulged in all kinds of extracurricular pleasure, Rilke now realized, while the poet had denied himself all joy. He pledged now to do "heart-work."

An opportunity arrived in 1919, when Rilke reunited with his old friend Baladine Klossowska, the Polish-born artist. Klossowska had recently separated from her husband and was living on her own with her two sons. Rilke immediately adored the boys: Pierre, fourteen, an aspiring writer, and Balthasar, eleven, a precocious artist whom Rilke preferred to call by the nickname Balthus. For perhaps the first time in his life, Rilke embraced the role of father and mentor, and the foursome soon became a family. They even had a cat, an adopted Angora stray named Mitsou.

One day Mitsou ran away and left Balthasar despondent. In response to the loss, he drew forty stunning drawings that depict the hours he and the cat had shared together. The series begins with Balthasar finding the cat on a park bench; it ends with a drawing of him weeping for his lost companion. Rilke was so struck by the inventiveness of the works that he arranged to have them published in a book titled *Mitsou*, and wrote the preface himself.

It's hardly surprising that in his later years Balthus remembered Rilke as "a wonderful man—fascinating." The themes Rilke raised concerning *Mitsou* accompanied the artist throughout his career as a preeminent painters of cats; for a while Balthus even signed his name "King of Cats."

Soon after they finished the book, Rilke's reclusive habits returned. He shut himself up for one more solitary winter, in 1922, during which time he authored the entirety of *Sonnets to Orpheus*. Baladine could not bear these bouts of isolation any longer. "We are human beings, René," she told him, and took the boys to live in Berlin.

The old lovers stayed in touch, however, and Rilke maintained close relationships with Pierre and, especially, Balthus. He arranged a job for Pierre in Paris as an assistant to his friend André Gide, and also encouraged Balthus, at the age of sixteen, to live and study art in Paris. Baladine kept Rilke updated on Balthus's progress. "He's beginning to have a public," she wrote. "René, he'll be a great painter, you'll see."

Rilke did see for himself when the young artist showed him an exquisite replica he had painted of Nicolas Poussin's *Echo and Narcissus* (c. 1630) at the Louvre. In its corner, Balthus added a dedication: "To René." That same year, 1925, Rilke dedicated to Balthus the poem "Narcissus," about a sixteen-year-old boy who is becoming an artist. ("His task was only to behold himself.")

The letters Rilke wrote to Balthus in those years are markedly different than those he had sent to the young poet Kappus two decades earlier. Whereas Rilke had shunned all practical advice in his earlier letters, and declined to offer any criticism of Kappus's poems, with Balthus he was full of praise for the artist's "charming" work as well as advice on all manner of practical concerns. He urged Balthus to "try, make a little effort" at school, even though it was "boring." The letters to Kappus are grandiose proclamations on love, death, sex, and life's other big questions. To Balthus, he recounted stories about his new cat, Minot.

But where these collections converge is in the presence of Rodin. The sculptor's teachings emerge in both books, offering an astonishing glimpse at the transmission of genius across mediums and generations. Rilke had always puzzled as a young man at the way Rodin would bid him goodnight by saying "*bon courage!*" But now he signed his letters to Balthus with the same words, having realized some years back how necessary courage is "every day, when one is young."

Perhaps the most significant lesson from Rodin that Rilke passed on to Balthus was not the sculptor's long-ago answer to the question "how should I live?" Instead, it came from the example of Rodin's life itself. Rodin once told Rilke that when he was young he read the devotional book *The Imitation of Christ*, and that every time he came to the word "God" he would replace it in his mind with "Sculpture." Rilke retold this story in his first letter to Balthus, advising him to do the same with the book contract enclosed for *Mitsou*. Coming to the end of his life, Rilke encouraged his own dethronement. "Replace my name everywhere with yours," he said, for although Balthus was legally a minor, he should nonetheless recognize the book as his own.

Rodin never questioned whether he was an artist. Rilke now urged Balthus to do the same, to not to shut himself off from the world as he himself had done for so long, but to stake his place decisively within it. See your name as the owner of this work, he said, and behold yourself: the artist.

Letters to a Young Painter

Rainer Maria Rilke

(all notes by the translator)

My dear Balthus, since the law says you still live closer to heaven, where no terrestrial commitments can reach you, I must bear on my own the enormous weight of this legal contract![1]

Here it is. As you can see, it unfolds like a perfect sonata, from first note to last, culminating in two very serious signatures. So let us take it with all due seriousness, and do our best to erect a public monument to Mitsou, who disappeared asking for no such thing.

Rodin told me one day that when he was reading *The Imitation of Christ* he used to mentally replace the name of God wherever it appeared with the word "Sculpture"—that is precisely what you must do in looking through this worthy document: replace my name everywhere in it with yours. For my contribution to your book will be much too minor to deserve the preponderant role assigned to me purely by the conventions of the contract. Your contribution was all the work and all the sorrow; mine will be paltry and nothing but pleasure.

Please read this document carefully and send it back to me; as soon as I have your agreement, I will sign the duplicate I have here and send it to Mr. Rentsch. I will also have our publisher send you the manuscript, so that at your leisure you can add the one missing drawing and the cover. I would like the manuscript back in its final state so that I can have it to look at while I work on the

preface. You'll see that they've let us take our time, but I imagine we will both be done with our work well before April 1, 1921.

My stouthearted castle keeps me shut up tight, let me assure you. I can't even leave the park, since the foot-and-mouth disease decimating the poor animals in the region has shut down the main roads. Otherwise I would have gone to Winterthur tomorrow, to say hello to your father at his lecture. I gather that he will have already left by next Monday; I received a letter from him yesterday, which I answered, telling him how sorry I am not to be able to see him again.

I am sometimes overcome with a true nostalgia for Geneva, which, by the way, as Mr. de Salis writes me, is suffering from a bad and quite unflattering case of "multicolor curtainitis." Good Lord, I wouldn't care about that—I'm sure the disease hasn't spread as far as the pleasant neighborhood around rue du Pré-Jérôme.

In any case, my conscience is quite clear about finding myself alone here with the demands of work, which I have been kept from for far too long by aggravating circumstances. Down there, with you, I am inclined to pour my heart out in that delightful freedom which friendship and affection permit me; here, my nature grows miserly and austere. Let us hope that it will emerge from its voluntary prison with something to show for it.

You will, of course, my dear boy, give your mother [2] my most affectionate greetings, with which I conclude this letter. I received her letter yesterday, and as always it was

delightful and diverting to read. Please likewise assure Pierre[3] of the warm and faithful friendship I feel for him. As for you, my dear Balthus, you surely know full well the love that binds us.

Yours with all my heart,

RILKE

Note:

Rilke wrote his preface two days later, on November 26. As he reported in a letter to Nanny Wunderly-Volkart on November 27: "Yesterday I started pacing back and forth outdoors at three thirty, thinking over my preface for Balthazar K.'s cat story, and at night (until almost midnight!) I wrote it in one go. The first piece of work I have written here, if you want to dignify it with that name. But I enjoyed bringing forth something in French—and it was thought in French, never once translated in my mind from a German idea." To Balthus's mother he wrote: "Last night I set to work and composed all at once my little preface to Mitsou. *I am very happy to include it here. . . . I also plan to send it to Vildrac, first to interest him in our publication so that he will stock copies of it, and secondly so that he can tell me frankly about any mistakes in the French that are too embarrassing—and there will be some!"*

Dear Balthus,

Do you know what has kept me from writing you all this time? Certainly not the fear of "spoiling" you with too fulsome praise.[4] I don't believe in this precaution that people think is educational: withholding reasonable praise from those who deserve it simply because they are young. On the contrary, I feel certain that we must express our approval, and if anything it is better to conceal our criticisms than suppress the joy of showing someone our pleasure—this joy does far more good to the recipient than the praise can harm him by overinflating his self-regard.

Anyway, in your case, my dear Balthus, there is nothing at all to fear: young as you are, your artistic instincts strike me as deep enough to bear within themselves an unconscious judgment, which, long before I came along, must have told you that these drawings, your spontaneous accompaniments to your memories of a Chinese story, are blessed with happy inspiration. I spend half an hour with your pictures almost every night, and each time find new reasons to be delighted. The inventions are charming; their facility proves the richness of your inner vision; the arrangement unfailingly highlights the excellent choices you made, more or less unconsciously, between the various possible elements in a rapid composition ... In short, to say no more, if we

could look at this series of four by three images together, we would have—you the artist, and I to whom you have given this charming gift—an entirely comparable pleasure, one might almost say the same pleasure. How could that be harmful?

No, my friend, if I am reluctant to draw your attention too much to my pleasure—our pleasure—it is because I am taking into account something I'm wrong to insist on but nonetheless feel I must. It's terrible that our schools don't start with their individual students' strongest aptitudes, they practically ignore these talents or even fight them, if they happen by chance to discover their unfortunate existence! I can imagine only too well the enormous difference between the intense and joyful attention you pay to these works of yours and the other, compulsory, dry, required attention they try to inculcate in you once you've set foot in the classroom. But my dear Balthus, at the moment how can I do anything but very unwillingly encourage the latter? This must be your exam period. I *very much* hope that your exams won't create an obstacle to your usual movements, the path you have to follow during these years. It seems to me that with an effort of will you will be able to rein in part of your *real* attention and direct it instead in the other direction, toward your schoolwork, most of it boring but unavoidable. This would not be a compromise—believe me—but a small act of generosity, taking place at the high level of your other talents. To do this for a little while would not change how school seems to you, but with the superior-

ity resulting from this effort you would be able to take from school everything that might serve your own ideas and individual interests. It's not as if school doesn't contain all sorts of things you'd enjoy; it's just that it doesn't manage, or manages only badly, to make contact and offer those things to you.

There you have it, my dear. Try, make an effort, there is nothing in life that doesn't produce a very valuable and ultimately individual pleasure if only we are a little persistent.

You weren't feeling well at Christmas, my poor Balthus ... I hope that you will enter into the new year happy, with renewed strength and confidence. As for me, I may well let myself be carried into 1921 in my sleep, and not see the new year until it is already several hours old. I have been writing all kinds of letters over the past few days, until my head is spinning, so as not to carry into the coming year the debts of correspondence I owe from this one. Out of my long list of several hundred names (now all crossed out), this letter to you will be the last to bear the old date. You see, I made sure to arrange for a happy ending.

It is up to you to start 1921 off right; try not to miss your chance, my dear friend, and bring Pierre and your dear Maman along with you.

RENÉ

Berg-am-Irchel Castle, Zurich Canton
[*late February, 1921*]

Balthus, my dear friend,

Many years ago, I met an English writer in Cairo, one Mr. Blackwood, who had put forth a very nice hypothesis in one of his novels: he imagined that every night, at midnight, a tiny gap opened up between the day that was ending and the one about to begin, and that a very nimble and clever person who managed to slip into that gap would escape from time and find himself in a realm free of all the changes we are subject to. All the things we have lost are gathered there—Mitsou, for example ... broken dolls from childhood, etc., etc.

My dear Balthus, that is where you must slip during the night of February 28 to claim your birthday party—it is hidden there and returns to the light of day only every four years![5] (I imagine that in an exhibition of birthdays other people's would look old and used up next to yours, which is well cared for, taken out of storage only at long intervals, looking quite resplendent.)

Mr. Blackwood, if I am not mistaken, called this secret noctural gap "the Crack"—and I advise you, for Pierre's sake as well as your dear mother's, not to disappear into it but only peer into it in your sleep. Your birthday, I'm sure, is waiting very close to the opening, you will see it right away, and perhaps you'll be lucky enough to catch a glimpse of other magnificent sights as well. When you wake up on March 1, you will find yourself full of these

sublime and mysterious memories, and instead of a party to celebrate you, the occasion will be one in which you generously delight others by telling them your stirring impressions and describing your rare birthday's splendid condition, absent but still intact and top quality!

This discreet birthday, living most of the time in a space beyond ours, must give you the right to many things that are unknown here. (It certainly seems to me more exotic and significant than a "Brazilian uncle.") I hope, my dear Balthus, that you will be able to acclimate some of these things to our world, so that they can grow here in spite of the problems caused by our uncertain seasons . . . a bit like what de Jussieu has done with the cedar of Lebanon that now adorns the Jardin des Plantes!

As for "our book," I am about to finish my final draft, taking advantage of a few edits that Vildrac suggested. I hope to send him the final text on March 1—in honor of your birthday. Let it be a good omen for our joint and brotherly success.

The other day, in Zurich, I had a little (very little!) parcel sent to you, for the day which is forced to stand in for your invisible birthday. I hope they'll be punctual. I myself will send, without fail, my sincerest best wishes, with all the friendship I have to offer you.

RENÉ

Balthus, my dear friend,

I owe you a nice long letter in response to your Christmas letter, and I owe Pierre one for his letter, too—but neither will be written today. I have written too much, my poor quill is all stubby from having made such long marches in almost all the countries of Europe and even farther; and I want it to be well rested for its "stationary" exercises, the work that must remain its favorite and regular "gymnastics."

But I must at least thank you, my dear, and very warmly indeed, for the pages you wrote to me. I thought the little Chinese ornamentation was *very lovely*; I'm sure you will have made others since. Are they a commission?

Here everything is proceeding as usual, and the regularity is a blessing I have great need of, so that I can resume my work and my thoughts, all of bygone times to some extent, in a world that does nothing but continue to move forward.[6] But your dear mother, she has been sick! Is she better now? She surprised me with such a sublime and touching gift—a spontaneous watercolor that she dashed off after an old photograph of my parents. It's amazing: the charm, the style, and, more than was even necessary, the truly accurate resemblance she was able to evoke in reproducing these effaced and rather evasive forms—an inspired work. Every day I admire it again and it never ceases to amaze me. Good Lord,

if the three of you could ever find yourselves back in a position to do what you're each capable of, if someone just gave you a little space and lifted all this useless depression from your shoulders ...

Rothapfel has sent you (from Heidelberg) the originals of *Mitsou,* hasn't he? (He promised me he would.) They aren't too badly damaged, I hope? I get a letter almost every day with kind words about *Mitsou*—I'll show you the most interesting ones sometime. I sent out a lot of copies between Christmas and New Year's.

So, my dear Balthus, *bon courage!* Winter will soon be over, and bright new ideas always return with the spring, and you emerge from under the Berlin clouds.[7] All the best to Pierre. I'm glad I chose something to his taste when I sent him the little Gide book. As ever, my dear partner in bookmaking, I remain your friend,

RENÉ

Dear Balthus,

In a few days you will once again celebrate the outward absence of your rare and discreet birthday. *Many happy returns*, my friend: let this year of your life about to commence be a happy and prosperous one—*despite everything*, I have to add, since it seems we have fallen back into the worst of the political turmoil that has already ruined so many years and that little by little deprives those of my generation of any reasonable future. It's different for you, you will see the dawn to come after this night engulfing our world; you *need* to see it and call it and prepare for it with all your strength.

Now that you've been to Muzot and seen the shops we have in Sierre, you will understand perfectly why I have no choice but to come to your party empty-handed … Frida baked you a cake, but it won't be able to come, poor thing. She just showed it to me and I had to agree it was neither transportable nor presentable. It's more of *a ghost story* than a cake! Frida told me in a toneless voice, eyes still wide from her doleful vision: "*At midnight, on the stroke of midnight, it half-collapsed!*" [8] Indeed, it is now a lunar cake, since if you look at it from one side only it admittedly looks magnificent, but that is not enough for a real Bundt cake, especially if you have to travel with it! She's planning to make another one, but I'm afraid

the mail is too slow, it probably won't reach you in time for the party.

And here comes Minot to wish you a happy birthday, my dear Balthus. She's an almost full-sized cat now, very smart, extremely sweet, and a big sleeper. The swipes are all used up, every last one, as we might have known they would be, and now she shows you her slow and empty paws with distracted caresses sleeping deep inside them.

Her kittenhood ended with a remarkable exploit: One night, a very cold night—I think it was still December—Frida (whose heart is not the most loyal) had forgotten her out in the snow. At around midnight, practically the very moment when cakes half-collapse, what do you think this little creature dreamed up? She must have been circling the house trying to find some hole she could slip in through, then, not finding any, she climbed (just think, she's so young!) up the tree next to the house, the plum tree, ventured all the way up to the top, then dared the magnificent leap onto my little balcony. From where, since the door is always open, she could come into my bedroom. I was woken up by her little voice, half plaintive, half angry, and at first I had no idea what she was doing there in the middle of the night ... A "prom-ising" display of intelligence, don't you think?

Lately she's been sleeping all night, every night, on the large woodburning stove in the dining room. As for her "job," mice hardly interest her at all, she chases flies and wishes she could chase birds. But luckily for them, they learn in their schools that cats don't have wings.

And you, my friend? How is the Academy of Art? You're going there now, right? And do they like your Oriental piece? Or are the events of the "Ruhr" preventing all that? (As they are everything …)

Be strong, have courage, my dear, and be in good health, that's all one can hope for when one is waiting. Very, very best wishes to Pierre and to your dear mother and your father, Balthus my dear.

Love,

RENÉ

Château Muzot-sur-Sierre (Valais)
February 27, 1924

Dear Balthus,

The day after tomorrow, for the first time in four years, you will finally accept a piece of actual birthday cake. It will be worth it, you'll see, since the following day you're off to Paris! This happy situation permits me to send you my wishes for an extraordinarily happy birthday, wishes which will quickly come true. So, my dear, leave for Paris and be happy. How could it be otherwise, considering that you have Paris to look forward to, and André Gide, and your brother, who you will all doubtless find is quite grown up!

Everyone here at Muzot is suffering somewhat this winter—even poor Minot, who has kept Frida from baking you a cake. Every night it takes Frida so long to wash and tend to the poor thing, who doesn't understand the treatment she's getting and wants only to escape these irritating treatments that don't feel nice and get her fur wet.

May I keep your Piero della Francesca a little longer?[9] I look at it slowly, lingeringly, and I imagine that you won't miss it during your first few days in Paris. There will be so many realities and so many other images in its place! If you do miss it one day, just let me know.

I send my love, my dear Balthus, and am happy for you!

RENÉ

Val-Mont par Glion sur Territet, Vaud Canton
February 24, 1926

Once again, my dear Balthus, you will have to put to-
gether a little party out of the eleven imperceptible in-
tervals between the chimes of midnight on February 28.
There cannot be many people who have such pure, hith-
erto entirely unseen material to make their birthday out
of; yours, being rare, has become a real collector's item.
So, from the miniscule elements of its absence, make a
lovely personal fabric on which others can rest their eyes
and place their best wishes on the morning of March 1.
And may your whole new year be productive, I mean us-
able for your deepest needs, whether or not you know
what they are yourself.

I have not forgotten, my good Balthus, the magnifi-
cent gift you made and gave me around the end of last
year: this copy is a beautiful work and I know that it will
speak to me always.[10] But please, I beg you, *don't think of
sending it to me* at the moment. For I'm not planning to
go back to Muzot right away, and if one day they find me
done for here,[11] your painting would be all alone there
with no one to enjoy it; that would trouble me. It has to
stay with you for the time being, so that you can show it
to your friends, and your friends' friends, and also so
that you can look at it more and be moved to make other
beautiful things, either after the old masters or after the
harmony being created between your imagination and
everything that happens to you. That said, I have to add

that I am proud of this *Narcissus,* and glad that it will someday come and enrich my immediate environment with its composite tenderness and this quantity of admiration it testifies to.

Since we're on the subject of Narcissus, might I ask you to talk to Miss Monnier for me about a favor? She may be able to help with something. Here are the main details: A series of books has recently started coming out in Paris, the *Série de l'Horloge*—twelve volumes, I believe, which are sold only to subscribers and only as a whole series, not individually. The first number, Cocteau's "Mutilated Prayer," has already appeared. I desperately wanted to be one of these subscribers, because the series will contain Valéry's "Notes on 'Narcissus,'" in which he plans to publish the various fragments of his "Narcissus." I don't yet know whether I will translate these poems someday,[12] but it is very important to me to own the introduction, which I am sure will be a very valuable addition to the fragments. I asked Miss Moone (in Zurich) to add me to the list of subscribers for the complete series, irrespective of the cost, since there was no other way to obtain the Valéry pamphlet—it will be extremely rare as soon as it comes out. However, the publishers in Paris have total contempt for orders from abroad, and the person in charge (I forget who the publisher is) stubbornly refused to accept the order, despite the insistence of good Mr. Morisse. He thinks that some booksellers in Paris have been guaranteed a certain number of copies for their clients; if, for instance, Miss Monnier is a client

of one of them, I would be delighted if you could arrange for me to subscribe to the whole series that contains the text I've mentioned. Let her know my predicament one of these days, in passing, could you?, and tell her that I place my last hopes in her, on the off chance that she will be able to help.

Well, my dear, I am very happy to hear that you have now met Jean Cassou and his family; I'm sure you will like him and will meet through him, if you haven't already, some charming gentlemen (for instance, the great and generous poet Supervielle!) and delightful women …

As for myself, my dear Balthus, I have a great desire to do and say nothing. If you imagine an evil wizard has changed me into a turtle, you won't be far from the truth: I now carry on my back a strong, hard carapace of indifference to all troubles, and even my head, when I do occasionally stick it out (a bad habit of mine), never receives any impressions that noticeably surpass the capacity of an average turtle's brain. This condition does certainly entail some ancient advantages, but I must admit that I haven't yet figured out how to take advantage of them. While I wait, I send my love, as though I were still the

RENÉ of the old days

(I send all of this to all three of you, by way of your birthday!)

P. S. This Middle Ages exhibition at the Bibliothèque Nationale, it must be astonishing! But did you consider going to see the seventeenth-century drawings of flowers and animals at the Pavillon Marsan? (It must be over by now, I suppose.)

My dear Balthus,

So you're about to travel again, and see once more this beautiful Italy that I have two steps away from me, and yet I never take these two steps! I have been invited to Milan, to Venice, to Florence … I have the necessary visa in my passport … but I am no longer "a traveling man," the least thing is enough to stop me, and none of the trains, not even the express the color of a maybug with all its banners that I see passing my balcony at Bellevue every day, tempts me in the slightest. I will end up with little bearded roots, and people will have to come by from time to time to water me (but not too much, that would remind me of cold feet).

My dear, I wanted to tell you: please don't set off without sending me your Poussin (*my* Poussin, I say with pride). It is as if my walls have changed their attire to receive it in dignified fashion: it will probably be their sole adornment. Most of the room has been prettied up, this time with green panels I came up with, and now I don't want to put the old engravings back where they were (however much I miss them, since they kept me very charming company …).

I would like to hear your opinion, Balthus, about J. M. Sert's church, currently on view in Paris. Have you seen the decorations, and did you subscribe to Claudel's article about them? (Some of it's wonderful.) He says there

must be a painter of our time who can pull off the miracle: creating entirely out of paint an inner lining to a cloak of God. Only a Spaniard or a Russian would be inclined to attempt so enormous a task in our era, this summa of painting that would have to be at the same time a summa of life and of faith. Send me a little note about it? If it wouldn't be too revolting for you to suddenly have a poor quill between your fingers instead of a brush, send word sometime, even if you're already in Italy. Where are you going first?

I hear that the French *Malte*[13] has come out, but I haven't yet seen a single copy; I'm going to telegraph Betz about it . . .

A thousand tokens of friendship to all three of you. With all my love,

RENÉ

1 Balthasar (Balthus) Klossowski was twelve years old, a legal minor. The contract was for *Mitsou: Forty Images by Baltusz* with a preface by Rilke. (Baltusz is the Polish spelling of his name.) In his letters, Rilke typically called the young artist "B.," but this translation spells out the name. Rilke signed his letters with the original spelling of his own name: René.

2 Balthus's mother, Baladine Klossowska, met Rilke in 1919. The two remained close until Rilke's death in 1926.

3 Balthus's brother, Pierre Klossowski, the future writer and translator.

4 Rilke charmingly undercuts himself by being uncertain of the word's grammatical gender: he writes "trop vives (vifs?) louanges," and below, "la (le?) louange."

5 Balthus was born on a leap day: February 29, 1908.

6 During the February following this letter, Rilke would at last write the second half of his *Duino Elegies* and the entire sequence of *Sonnets to Orpheus* in the space of only three weeks.

7 Financial problems had forced Baladine to move to Berlin with Balthus and Pierre in the spring of 1921, where they stayed with her brother.

8 Frida's statement and the words "a ghost story" are given by Rilke in German.

9 A copy by Balthus of a Piero della Francesca painting.

10 This was a copy of Nicolas Poussin's *Echo and Narcissus*, made in the Louvre in 1925. Rilke had dedicated a poem, "Narcissus," to Balthus in January 1925; Balthus wrote "À René" on a rock in his painting.

11 Rilke would die at the end of this year, on December 29, 1926.

12 Rilke would translate the poems that summer.

13 *The Notebooks of Malte Laurids Brigge,* Rilke's 1910 novel, translated into French by Maurice Betz.

Preface to *Mitsou: Forty Images by Baltusz*

Rainer Maria Rilke

Cats—who truly knows them? Do you, for instance, claim to know cats? I confess that for me their existence has never been anything but a relatively bold hypothesis.

For if animals are to share our world, they must enter into it, must they not? At least a little. They have to conform to our way of life to some degree; have to tolerate it. If they don't, if they remain distant or hostile, their sole connection to us will be to mark the distance that separates them from us.

Consider dogs: Their attitude to us is so full of trust and admiration that some of them seem to have renounced their most venerable canine traditions in order to worship our ways and even our faults. That is just what makes them tragic and sublime. Their decision to acknowledge us forces them to live at the limits of their nature, so to speak, constantly on the brink of crossing those limits, with their humanized looks and nostalgic puzzlings.

But what about cats?—Cats are cats, period. Their world is utterly and completely the world of cats. You say they look at us? I say: Has anyone ever truly known whether or not they deign to register our trifling image on the back of their retinas for even a moment? Perhaps, while directing their eyes toward us, they simply exclude us from their already complete gaze with a magic refusal.

It is true that some of us indulge our willingness to believe in their wheedling, electric caresses. But let these people recall the strange, abrupt, distracted way that

their favorite animal so often cuts short these effusions, which they had thought were reciprocal. They, too, these privileged humans allowed to live among the cats, are time and time again rejected and disavowed; even while they hug the mysteriously apathetic creature to their breast, they feel themselves stopped at the border to this world, the world of cats, inhabited by cats alone in circumstances and situations that none of us have the least inkling of.

Has any man been their contemporary? I doubt it. And I can assure you that sometimes, at twilight, the neighbor's cat has leapt right across my body not even knowing I'm there, or else to prove to the stunned things looking on that I do not really exist at all.

Am I wrong to offer these thoughts when what I want is to lead you into the story my young friend Baltusz is about to tell you? He will tell it in drawings, true, with no words, but his pictures will more than satisfy your curiosity. Why, then, should I repeat them in another form? I would rather add something he has not said already.

Still, let me summarize the story:

Baltusz—I believe he was ten years old at the time—finds a cat. This was at the Nyon Castle, which you're probably familiar with. He is allowed to keep his trembling little treasure, and off they go! Here is the boat, the arrival in Geneva, at Molard; here is the streetcar. He introduces his new companion to domestic life, tames him, pampers him, loves him. "Mitsou" is happy to accept the conditions Baltusz lays down, although occasionally he

breaks the household monotony with various frisky, innocent improvisations. Do you think it's a bit much that his master takes him out for walks on the end of that embarrassing string? It's because the boy is leery of all the ideas and desires that might enter this tomcat's loving but mysterious and adventurous heart. Yet the boy seems to be mistaken. Even the perils of moving house go off without a hitch, and the capricious little creature adapts to his new surroundings with amused docility. Then, without warning, the cat disappears. An alarm goes up in the house; but heaven be praised, this time it's nothing serious. Mitsou is found on the lawn, and Baltusz, far from chastising his little deserter, tucks the cat in on the cozy pipes of a benificent radiator. No doubt you, like me, will savor the peace and relaxation that follow this scare. Alas! They are not to last. Christmas is sometimes all too full of temptations. Cakes are eaten, perhaps without keeping count; the boy falls ill. To recover, he sleeps. Mitsou gets bored by this nap lasting too long, and instead of waking you up, he runs away. The shock, the alarm! Luckily, Baltusz has recovered enough to throw himself into pursuit of the fugitive. He begins by rummaging under his bed: nothing. How brave he looks, don't you think?, all alone in the basement, with the candle he carries everywhere from then on as the emblem of his searching—in the park, on the street. Still nothing! Behold his small, solitary form. Who has abandoned him? A cat?—Will he be able to console himself with the portrait of Mitsou that his father

has recently sketched? No. If anything, the picture was a kind of premonition—a bad omen. God knows when the fate of losing the cat was actually decreed! Now it's certain: it has happened, the cat is lost. Baltusz returns home. He is crying. He shows you his tears with his own two hands:

Look closely at them.

And that's the story. The artist told it better than I did. What else is left for me to say? Not much.

*

It is always nice to find something. Just a moment before, it hadn't been there. But to find a cat is incredible! For you must admit that the cat never totally enters our life the way, for example, a toy does. While it belongs to you now, a little remains outside, and that means we always have:

life + a cat,

which adds up to an enormous sum, I assure you.

It is very sad to lose something. We can imagine only that it is suffering, it has hurt itself somewhere, it will come to a sad end. But to lose a cat—no! It cannot be. No one has ever lost a cat. Can one lose a cat, a living thing, a living being, a life? To lose a life is death!

Well, then, it's death.

Finding. Losing. Have you truly considered what it means to lose something? It is not simply the negation of that other, generous moment that answered an expectation you never suspected you had. For between that moment and the loss there always comes what we call—however clumsily, I agree—possession.

Now a loss, however cruel it may be, has no power over possession. It ends the possession, if you wish; it affirms it; but ultimately it is a second acquisition, entirely inward this time, and far more intense.

You yourself have realized this, Baltusz—no longer seeing Mitsou, you truly set about seeing him.

Is Mitsou still alive? Well, he lives on in you, and his joy, that of a frisky little kitten, after once having entertained you, now compels you: you have had to express it by means of your painstaking sadness.

And so, a year later, I found you had grown bigger, and were consoled.

Still, for those who will always see you bathed in tears at the end of your book, I composed the first, somewhat fanciful part of this preface. To be able to tell them at the end: "Don't worry: I am. Baltusz exists. Our world is whole.

There are no cats."

Rainer Maria Rilke
Berg-am-Irchel Castle
November 1920

Losing the Unknown

Marc de Launay

for Marie, Marion, Perrine, and Juliette

When the Great War came to an end, Rainer Maria Rilke wanted only one thing: to find a place that would allow him to recapture the "miracle" of Duino, those few days in 1912 when, looking out on the Adriatic, he had put the first *Elegies* down on paper. It was not only about finding a place, of course—the cluster of conditions necessary for recreating such a strong and intense creative readiness depends only partly and indirectly on the environment. Still, the poet absolutely had to leave Germany, which was too closely associated with the war years and the "aridity of the soul"[1] that had lasted too long; as he wrote in 1919, "the unswerving intellectual could side with neither party in this chaotically confused struggle, which the poison of the stagnated war—turned back as it was into the country—further and further provoked: neither with those who drove ruthlessly ahead nor with those who met the often criminal outbreaks of this insanity with old and no less unjust and inhuman means. The future lay with neither, and it is to the future that the intellectual is allied and sworn, after all."[2]

The first few months of his time in Switzerland consisted of constant, almost feverish wandering. Rilke accepted the hospitality of numerous people, went from lectures to trips, from old friends to new acquaintances, including his decisive meeting with Baladine (Merline) Klossowska and her sons Pierre and Balthasar (Balthus) Klossowski in Geneva in October 1919. Rilke spent the whole winter of 1919–1920 traveling in Ticino, in southern Switzerland; the spring of 1920

found him near Basel, staying in the Burckhardt house at Schöneberg. After a trip to Venice, a stay in Zurich, and another in Winterthur, Rilke met Baladine in Geneva again before taking a side trip to Beatenberg.[3] Bern, Fribourg, Zurich, Geneva once more in the autumn— where Rilke interceded with the principal of a school on Balthus's behalf—then Bad Ragaz, Zurich, Geneva, Sierre. It was there that he first saw the series of drawings by Balthus bearing the title *Mitsou*.[4] The rounds continued—Geneva, Bern, Basel, Paris, Geneva—only coming to a stop on November 12, 1920.

The castle of Berg-am-Irchel, near Zurich, was where Rilke would stay from then until May 1921. Winter, a castle, isolation, staying in one place: at last he seemed to have found a situation recalling his sojourn in Duino,[5] the castle of the Princess von Thurn und Taxis near Trieste, and anticipating his circumstances during the winter of 1921–1922, when, alone in a castle in Muzot, he would write the last elegies and the *Sonnets to Orpheus*,[6] fulfilling the main goal of his time in Switzerland and marking the culmination of his creative life.[7] In the meantime, he described to Merline what he hoped for from his winter solitude:

> Please do not expect me to speak to you of my inner labor—I must keep it silent; it would be tiresome to keep track, even for myself, of all the reversals of fortune I will have to undergo in my struggle for concentration. This sudden shifting of all one's forces, these

about-faces of the soul, never occur without many a crisis; the majority of artists avoid them by means of distraction, but that is why they never manage to return to the center of their productivity, whence they started out at the moment of their purest impulse. At the onset of every work, you must recreate that primal innocence, you must return to that ingenuous place where the Angel found you, when he brought you that first message of commitment; you must seek through the brambles for the bed in which you then slept; this time you won't sleep: you will pray, wail—anything; if the Angel condescends to come, it will be because you have persuaded him, not with your tears, but by your humble decision always to start afresh—*to be a beginner!* [8]

The solitude he found at Berg-am-Irchel was thus explicitly devoted to moving beyond the "distraction" caused by agitation and his various activities; his isolation was meant to let the creative rebirth he so longed for emerge from the depths.

And yet, except for the "Posthumous Poems of Count C. W.," published mainly after Rilke's death, and a little poem written in December for Nanny Wunderly-Volkart, called, in a sad paradox, "Nikè" ("Victory"), plus a few sketches and drafts, [9] Rilke did not reach the state of radical austerity in which he could finally open himself up to what was he sensed was still to come:

I have done wrong; betrayal. After six years of destruction and obstruction I have not made use of the circumstances that were offered me with B[erg-am-Irchel] for the undeferrable inner task; fate has wrung it from my hands.... On December 2nd, right after the joyful attempt to draft that Préface in French, I succeeded in writing down the first lines of that work in which my new inner integration was to express itself. On the 4th I was interrupted through the disagreeable task of my birthday correspondence, on the 6th the first disquieting news reached me from Geneva.... You see, I am stuck with my small miscarriage of December 2nd; the work, the life that fulfills me, gave itself away in it.... My heart had been jolted from the center of its circles toward the periphery, there where it was closest to you—why, there it may be big, full of feeling, jubilation or anxiety—it is not in its own constellation, it is not the heart of my life.[10]

Rilke's love for Baladine and affection for Balthus [11] were not, in fact, truly responsible for his failure—they were evidence of the fact that Rilke had turned away from the essential: "I knew it all winter: I have to think myself towards something. Alas—this is the worst loss: to have lost something unknown, something unguessable." [12] Still, it must be emphasized that, in Rilke's eyes, the preface to *Mitsou* was neither an unfortunate distraction nor an unsuccessful sketch, nor a stopgap, much less a temptation to evade his primary task; on the contrary, it came

in this initial phase full of hope, full of energy and joy. At the same time, it concerned a loss: the loss of a beloved pet, but with many other possible overtones—the loss of childhood, the end of a strange relationship with an animal discovered by chance that had mysteriously vanished, and one able to embody the most complex symbolic structures.

In addition, the preface marked an important beginning of a sort, as the first publishable literary text Rilke ventured to write directly in French.[13] In a special issue of the journal *Les Lettres* devoted to Rilke in 1952, Charles Vildrac offered readers this letter from Rilke, dated December 13, 1920:

This time it is I who am going to ask you a favor. I wrote the modest preface you see here for a young friend (twelve years old), whose lovely collection of drawings is going to be put out by a publisher in Zurich; I am very proud of the piece, because I can truthfully say that I thought it in French. Young Balthuz (Polish) is the son of the painter Erich Klossowski, living in Saint-Germain at the moment, whom you might remember. When he was barely eleven years old he retold, in forty images, the adventures of a cat he had found and then lost, which he would stay upset about for a long time; he turned it into a work that is so charming, created by so sure a hand and so ingenuous a talent, that I found myself wanting to arrange for its publication. Since it contained only

Balthuz's drawings, with no text by him, I thought it would be appropriate for me to add a few pages as a prelude.

As you will see from it, I do not intend our book just for children; the language of these sketches, while sometimes quite casual, is likely to interest grown-ups just as much, and both Balthuz and I would be flattered if the art salon on rue de Seine would be willing to help us win over some well-meaning admirer. But that will come later.

For the moment, my dear Vildrac, ... I send you my prose, which, while seeming quite easygoing, obviously requires a strong hand to guide it a little and, if need be, ruthlessly correct it.... I would otherwise never dare show myself in public with this bustling little improvisation, which clearly cannot come under the jurisdiction of my artistic conscience. I feel too much "in the trade" to abuse this supreme instrument, your language, and I am almost afraid to have touched its strings, whose most secret sensitivities I may well not be aware of. So please save me from the censure with which my work might deservedly be met.[14]

Rilke's preface is a strange text, if for no other reason than that it refrains from passing any judgment on the main part of the book—the india ink drawings by Balthus—but also because it gives the impression of hesitating between various main lines of approach. From

the beginning, the main subject is cats, although their very existence is described as a bold hypothesis, both right at the start and in the conclusion, which ends by affirming: "There are no cats." An even stranger effect is produced by the passage Rilke devotes to the loss itself, culminating in a total denial that it has taken place at all: "A loss ... has no power over possession ... it affirms it; but ultimately it is a second acquisition, entirely inward this time, and far more intense." [15] There is no longer a "loss" if that which was "possessed" was possessed by an artist; and there are no cats in the strict sense because they can only exist in a different sense, a different dimension, the one in which such a cat is supposed to designate a loss of one knows not what.

The mystery of a cat's disappearance is as great as the mystery of its appearance, just as the name it is given is fundamentally mysterious—or rather, the mystery is how cats have the special ability (among other equally unusual abilities) to incarnate the names they are given. They embody the qualities these names seem to entail, and do not disappoint the expectation that arises in such a surprising way merely from the conjunction between a name and a particular animal. The cat named Critique may spend hours watching its master write and then suddenly show its silent reprobation with a blow of the paw aimed right at the top of the pen that has been interminably tracing its serpentine black indecipherabilities across the page. It also knows how to conceal under the carpet (but carefully placed in line with the door to

the office, so that you necessarily step on it when you walk into the room) the very pen its master was most recently writing with—never any other—no doubt having reached the last straw of jealousy. The cat Gallimart, wherever it happens to be, elegantly spills the black stain that its eponymous medieval inkwell contains; it sometimes copies, not without irony, the inkwell itself, when it curls up like a snail—but it takes great care to preserve the ambiguity every time someone says its name.[16] The cat Comma, bearing on its brow a ginger curl just like the punctuation mark, gives a teeming, teasing, bouncing, and sometimes boldly laughing interpretation to this typography, and, just as the comma is said to separate two ideas, this cat takes every opportunity to interrupt anything that threatens to reestablish syntactic continuity, any too pedantic legato, with its comic syncopes or audacious parataxes. We need hardly mention what feline and devilish seductions and unions the cat Strumpet manages to pull off . . . And how does the cat roaming the Grand Chalet of Rossinière [17] behave? Its name is Fantômas, after the criminal mastermind; and just knowing that there is also a dog Fandor there, named after his nemesis, lets us picture the parody that these two animals create of the *feuilletonesque* style and the pulp novel, idiosyncratically but effectively extending Allain and Souvestre's work.

For Rilke, the cat is even less confined by the boundaries of reality than the phantom:

Black Cat

A ghost is still a place
your sight can bump into, knock against;
but when it hits this deep black fur
even your strongest gaze evaporates:

the way a lunatic, raving in maddest
rage, hurling himself into blackness,
suddenly stops at the padded walls
of his cell and is soothed and drained away.

All the looks that have ever struck this cat
she seems to conceal upon her
so that she can look them over
like a menacing sullen audience, sleep with
 them there.
But suddenly, as if startled awake, she turns
her face directly to yours:
and now you unexpectedly find once more
your gaze in the yellow amber
of her eyeballs: suspended there
like some prehistoric insect.[18]

One can meet the gaze of the cat only with the gaze of
the artist—"no longer seeing Mitsou, you truly set about
seeing him"—especially if the vanished cat "survives," as
Rilke claims, within its master.

Balthus, today, explicitly recognizes that "the more you contemplate an object, the stranger it becomes." [19] Albert Camus, in discussing Balthus's style, realized that the first analogy should be that of a feline gait: "Balthus moves like the cats he so loves to paint." [20] Claude Roy argued that Balthus had a feline nature from the start—"Balthus has been a cat since childhood" [21]—for, not knowing what he had lost with Mitsou, he never ceased to pursue its recapture by creating in his paintings what his brother, Pierre, defined as "dramatic expectation": Balthus's canvases stubbornly give the impression of an event about to occur before the viewer's eyes. Jean Starobinski, recalling the time when André Malraux and Balthus met in Geneva and discussed cats, drawing them on the tablecloth, [22] emphasized "the taste for drama as one of Balthus's greatest predilections." [23]

Discovery and loss are the two diametrically opposed moments that, from Balthus's earliest work, shaped his development and organized in Balthus himself, perhaps, the mysterious relations that would later be created between vision and that imperceptible thing which it always contains: the pleasure of painting, of recapturing—in the slightly differing drama the painter stages for himself, making it emerge bit by bit on the canvas like an indefinite crisis in the process of being resolved—the eroticization of imminence which is the very essence of both encounter and disappearance. [24] The black cat—Mitsou in india ink—presents colors and contours that, in each of its movements, harmonize everything around

it; it is the blind spot of representation, the point of view, strictly speaking, of the creative imagination whose contingent pretext is a lived series of events; and yet, at the same time, this point of view can now be transposed onto a symbolic plane, multivalent and lasting: "The cat may be for the painter what the mirror is in the painting—a kind of emblem, a signature no less insistent for being secret." [25] In the pictures themselves, the cat always introduces a unique constellation combining the riddle "of the Sphinx" and playful flirting, in short, everything that partakes of innocent, untamed wildness, without any menacing fury; but it is also the contradictory union of sedentary familiarity and disturbing cruelty, serene sweetness and sudden unpredictable predatoriness, the borders of the untamed world and the threshold of domestication, in short, the end of childhood, even if this frontier traces a different line in each of us.

Balthus made his debut with this series of ink drawings, evocative enough of the creative situation as such that Rilke—living in the hope of seeing what he himself had lost come into view once more; literally spending his time writing "in a pure state of loss," though without knowing what it was that had disappeared, in order to clear the deep terrain of essential receptivity in himself that he knew he had to find once more—could recognize in *Mitsou* his own situation, and could help transform, out of affection for a creative soulmate, the anecdote into a true story, a private effort, a first work of art. From that point on, cats would haunt this painter, or at least he

would make them haunt his canvases—he, the "King of Cats." "How much this *King of Cats*" in the painting of that name "reminds one of the young Delacroix dressed as Hamlet! Or, even more, of Baudelaire's portraits of himself, essays in self-definition and self-affirmation! For here, too, there is a conflict. Different as he is from Balthus, the cat is Balthus himself. It signifies … the more obscure being which is subject to the law of desire and remains, for better or worse, allied to the reality of things." [26]

Since 1977, Balthus has been working on a painting which currently exists in three versions: *Cat at the Mirror* …

1 This is the expression Rilke used in a letter to Lisa Heise, written on August 2, 1919, in Soglio. He had arrived in Switzerland on June 11.

2 Letter to Countess Aline Dietrichstein, 6 August 1919, in *Letters of Rainer Maria Rilke: 1910–1926,* trans. Jane Bannard Greene and M. D. Herter Norton, pp. 195–196. Here and elsewhere, earlier translations have been emended slightly.

3 In August 1922, Rilke returned to Beatenberg with Baladine and Balthus; it was on this trip that several famous photographs of the three of them were taken.

4 Letter to Madame Strohl, 30 November 1920: "You too, I am sure, have already seen us in the salon of the Villa Baur … paging through the little book of 'Mizu.' It is to you, Madame, that all the honors it will ever acquire in the world will be owed." *Mizu*, later spelled *Mitsou*, was "drawn in secret a year after the loss of 'Mitsou,' as a kind of journal." Letter to Countess Nora Purtscher-Wydenbruck, 12 January 1922.

5 "The castle of Berg-am-Irchel, owned by a Swiss colonel named Ziegler, is to be my place of abode for the next few months, perhaps for the winter. Under conditions somewhat resembling those in Duino: that was what settled it for me." Letter to Marie von Thurn und Taxis, 19 November 1920, excerpted in *Letters, 1910–1926,* p. 227.

6 Letter to Lou Andreas-Salomé, written in Muzot on Saturday, February 11, 1922, at six o'clock in the evening: "At this moment I am laying aside my pen after the last completed Elegy, the tenth…. It was a hurricane, as at Duino that time…. Now I *know* myself again. It really had been like a mutilation of my heart that the Elegies were not—here." *Letters, 1910–1926,* pp. 292–293.

7 "I find myself in such an unusual situation inwardly because of that lengthy, forced hiatus and because I must return to those emotions which, while very worthy, nevertheless bear the date of 1912. A little longer and I may lose all understanding of the conditions under which these songs, begun so long ago, arose…. When I scrutinize my conscience I see but one law, and that pitilessly categorical: to shut myself away within myself, and in one blow to finish the task that was dictated to me in my heart's core." Letter to Baladine Klossowska, 16 December 1920, in *Letters to Merline, 1919–1922,* trans. Jesse Browner, p. 44.

8 Letter of 18 November 1920, in ibid., p. 29.

9 See "The Origin of the Smile" and the sketch of an elegy beginning "Do not admit that childhood was …"

10 Rainer Maria Rilke, "Testament," in *4 × 1*, trans. Pierre Joris, pp. 123–124. Translation originally published in *Sulphur* 30 (Spring 1992), www. webdelsol.com/Sulfur/Rilke_text.htm.

11 On November 18, 1920, Rilke wrote: "Beloved: embrace Balthus for me (without telling him). I am sorry I didn't do so myself; it's one of those silly discretions one scolds oneself for afterwards. When I return I will do it, with all the tenderness I feel for him. I spoke with his publisher by telephone; we're going to draft the contract sometime soon, only I alone will append my signature, because Balthus, being a minor, cannot enter into any contract." *Letters to Merline*, p. 32.

12 Rilke, "The Testament," p. 118.

13 See the letters of November 27 quoted in the note on p. 18, above.

14 *Les Lettres*, vol. 4, no. 14–16 (1952), pp. 37ff. Vildrac replied on February 21, 1921, suggesting a number of corrections, almost all of which Rilke incorporated. On February 23, Rilke sent a corrected copy of the preface to Baladine for her opinion about certain decisions; the final manuscript was sent to the publisher at the end of February. Rilke corrected the proofs in May, and Eugen Rentsch, the head of Rothapfel, sent him second proofs on June 8. The little book was published during the summer of 1921, probably in August. Rilke made two handwritten copies of the earlier draft of the preface, one for Carl J. Burckhardt (20 December 1920) and the other for Katarina Kippenberg (23–24 January 1921). Balthus gave the forty original drawings to Rilke for Christmas in 1922. See Rilke, *Werke*, VI.1498–1501.

15 A poem by Rilke written in French includes the lines: "Love, I know, is a loss / hidden by an act of taking." Another poem in French evokes the theme of loss again: "Does this remind you of lost things the next day? / They beg you one last time / (in vain) / to stay with you. // But the angel of losses has brushed them with his distracted wing; / ... They have received, we don't know when, / the stigmata of absence; / ... They are about to leave these ordered ranks / of the possession that gave them their name." Rilke, *Werke*, II.695 and II.666.

16 [Translator's note: The ambiguity here is between "Gallimart" and the famous publishing house Gallimard, pronounced the same in French.]

17 [Trans. note: Balthus's château.]

18 "Schwarze Katze"; for other translations, see *The Selected Poetry of Rainer Maria Rilke,* trans. Stephen Mitchell, p. 65; and *New Poems [1908]: The Other Part,* trans. Edward Snow, p. 99. Rilke did not write as much about cats as did, for instance, Charles Baudelaire ("Seraphic cat, strange cat / In whom all is like an angel … Perhaps he is a fairy, or a god?" ["The Cat," in *The Flowers of Evil*]). Aside from "Black Cat," Rilke called only one other poem "Cat," in the sequence *Exercices et évidences*: "The show cat: a soul conferring / its slow dream on all those scattered objects, / and in primal consciousness bestowing / itself to a whole unconscious world" (*Rainer Maria Rilke: The Complete French Poems,* trans. A. Poulin, Jr., p. 213). One cannot help thinking, perhaps, with regard to this cat and its disappearance, of the Cheshire Cat that Lewis Carroll discovered (or invented?)—whose smile alone remains after the rest of it vanishes, like smoke from an extinguished candle. Charles Cros wondered about the cat "what secret sleeps in its green eyes"; Pablo Neruda "saw the rolling waves of the cat as it sleeps; night flows in it like dark water"; Paul Morand recognized that "cats are misunderstood because they do not deign to explain themselves, enigmatic only for those who do not know the expressive power of mute silence"—those who, like Alexandre Dumas, hold that the cat is "aristocratic in type and origin"; everyone agrees with Lucie Delarue-Mardrus's description: "the cat, stealthy monarch."

19 See Barbara Basting, "Die Katze, die Kugel und die Königin" [Cat, Ball, and Queen], *Du,* issue on "Balthus: Ein Unbehagen in der Moderne" [Balthus: Modernity and Its Discontents] (September 1992), pp. 20–28. Yves Bonnefoy, writing in 1957, went deeper: "Perhaps, by snatching at it so brutally, Balthus frightens off what he depicts. Or perhaps he is compelled to be brusque by the welling up of absence, revealed and emphasized by the sudden influx of childhood memories." See "The Decisions of Balthus," trans. Michael Sheringham, in Yves Bonnefoy, *The Lure and the Truth of Painting: Selected Essays on Art,* ed. Richard Stamelman, p. 131.

20 *Balthus,* exh. cat. (New York: Pierre Matisse Gallery, 1949), preface. About Balthus's style in general, Camus writes: "A painter's style is essentially a certain way of uniting the natural and the impossible, of presenting what is always in the process of becoming, and presenting it in an instant that never ends."

21 "Notizen zu Balthus" [Notes on Balthus], *Du* (September 1992), p. 11.

22 "Malraux, Balthus et l'idée du chat" [Malraux, Balthus, and the Idea of the Cat], *Du* (September 1992), p. 18.

23 *Balthus* (Lausanne: Skira, 1993), p. 71. Slightly later in the same essay, Starobinski is even clearer: "His painting ... is the prime example of an art that, far from consenting to forgetting, insists on presenting the memory of a time when nothing was separated."

24 Jean Clair speaks of an "infinite incompleteness of childhood" with regard to Balthus's canvases showing scenes of children. See "Les métamorphoses d'Éros," in *Balthus,* exh. cat. (Paris: Centre Georges Pompidou, 1983), p. 266.

25 Ibid., p. 275. Clair, for his part, recognizes that the cat is "an animal outside of creation, whose presence among us remains a mystery."

26 Bonnefoy, "The Decisions of Balthus," p. 130. A nonexhaustive list of works by Balthus containing cats would include: *The Quays* (1929), *The King of Cats* (1935), *Young Girl with Cat* (1937), *Thérèse Dreaming* (1938), *Study for "The Golden Days"* (1944), *Girl with Goldfish* (1948), *Goldfish* (1948), *Goldfish and Candle* (1948), *The Week of Four Thursdays* (1949), *The Cat of La Méditerranée* (1949), *The Room* (1952–1954), *Nude with Cat* (1954), *The Game of Patience II* (1954–1955), *The Three Sisters* (1966), *Cat at the Mirror I* (1977–1980), *II* (1987–1990), and *III* (1990–1993), *Large Composition with Raven* (1983–1986), and more. [Trans. note: Many of these are brought together in the recent exhibition catalogue *Balthus: Cats and Girls,* ed. Sabine Rewald (New York: Metropolitan Museum of Art, 2013).]

RAINER MARIA RILKE (1875–1926) was a poet and novelist, best known for his highly lyrical poetry. He was born in Prague, but spent significant portions of his life in Paris, where he initially served as the sculptor Auguste Rodin's secretary before going on to produce much of his important early work. Throughout his life, Rilke was continuously inspired by works of visual art. His biography of Rodin and his *Letters on Cézanne*, published posthumously, provide insight into the way visual artists, and their art, figured into his creative approach, and establish him as one of the key twentieth-century poets to engage with visual culture.

RACHEL CORBETT is the author of *You Must Change Your Life: The Story of Rainer Maria Rilke and Auguste Rodin* (2016, W. W. Norton), which won the 2016 Marfield Prize, the National Award for Arts Writing. Translations are forthcoming in German, Czech, Turkish, Korean, and Russian. She has also written for the *New Yorker*, the *New York Times*, the *Art Newspaper*, *New York* magazine, and other publications. She lives in Brooklyn.

DAMION SEARLS has translated thirty books from German, French, Norwegian, and Dutch, including *The Inner Sky: Poems, Notes, Dreams* (2010, David R. Godine), a selection of writings by Rainer Maria Rilke. His translation awards include Guggenheim, Cullman Center, and two National Endowment for the Arts fellowships. He is also the author of three books, most recently *The Inkblots* (2017, Crown), a scientific and cultural history of the Rorschach test and biography of its creator, Hermann Rorschach.

"Ekphrasis" is traditionally defined as the literary representation of a work of visual art. One of the oldest forms of writing, its meaning originated in ancient Greece, where it referred to the practice and skill of describing people, objects, and experiences through vivid, highly detailed accounts. Today, ekphrasis is more openly interpreted as one art form, whether it be writing, visual art, music, or film, being used to define and describe another art form in order to bring to the audience the experiential and visceral impact of the subject.

By bringing back into print important but overlooked books—often pieces by established artists and authors—and by commissioning emerging writers, philosophers, and artists to write freely on visual culture, David Zwirner Books aims to encourage a richer conversation between the worlds of literary and visual art. With an emphasis on writing that isn't academic in the traditional sense, but compelling as prose, and more concerned with subject matter than historical reference, *ekphrasis* invites a broader and more varied audience to participate in discussions about the arts. Particularly now, as visual art becomes an increasingly important cultural touchstone, creating a series that encourages us to make meaning of what we see has become more compelling than ever. Books in the *ekphrasis* series remind us, with refreshing energy, why so many people have dedicated their lives to art.

Letters to a Young Painter
Rainer Maria Rilke

Translated from the French
Lettres à un jeune peintre

Published by
David Zwirner Books
529 West 20th Street, 2nd Floor
New York, New York 10011
+ 1 212 727 2070
davidzwirnerbooks.com

Editor: Lucas Zwirner
Translator: Damion Searls
Copyeditor: Deirdre O'Dwyer
Project Assistant: Molly Stein
Proofreader: Deirdre O'Dwyer

Design: Michael Dyer / Remake
Production Manager: Jules Thomson
Printing: VeronaLibri, Verona

Typeface: Arnhem
Paper: Holmen Book Cream,
80 gsm

Publication © 2017
David Zwirner Books

Introduction © 2017 Rachel Corbett
Translation © 2017 Damion Searls

"Losing the Unknown," by Marc
de Launay, was originally published,
in French, in *Lettres à un jeune
peintre* in 1998 by Somogy and
Archimbaud, Paris. Translated and
printed with permission.

First published 2017
Second printing 2020

Distributed in the United States
and Canada by
Simon & Schuster, Inc.
1230 Avenue of the Americas
New York, New York 10020
simonandschuster.com

Distributed outside the
United States and Canada by
Thames & Hudson, Ltd.
181A High Holborn
London WC1V 7QX
thamesandhudson.com

ISBN 978-1-941701-64-5
LCCN 2017949027

David Zwirner Books

ekphrasis